P.

C

MA

Geo

Please return this book on or before the date shown above. To renew go to www.essex.gov.uk/libraries, ring 0345 603 7628 or go to any Essex library.

Essex County Council

This edition published in the UK in 2015 by
Ivy Press
210 High Street, Lewes,
East Sussex BN7 2NS, U.K.
www.ivypress.co.uk

First published as part of *The Calligraphy Kit*

British Library Cataloguing-in-Publication Data
A catalogue record for this book is available
from the British Library

ISBN 978-1-78240-279-4

This book was conceived,
designed and produced by
Ivy Press
CREATIVE DIRECTOR Peter Bridgewater
PUBLISHER Sophie Collins
EDITORIAL DIRECTOR Steve Luck
DESIGN MANAGER Tony Seddon
DESIGNER Andrew Milne
SENIOR PROJECT EDITOR Rebecca Saraceno

Printed and bound in China

Colour origination by
Ivy Press Reprographics

10 9 8 7 6 5 4 3 2 1

Distributed worldwide (except North America) by
Thames & Hudson Ltd., 181A High Holborn,
London WC1V 7QX, United Kingdom

Contents

Introduction

CALLIGRAPHY IS WRITING AS an art—beautiful writing. But what makes one person's writing more attractive than another and when does handwriting become calligraphy? We can all recognize consistency in writing: the regularity of the letter shape, height, and width, straight lines and a rhythmic pattern to the text. But what is the difference between good handwriting and calligraphy?

We tend to apply the term "calligraphy" when a text has been written with the intention of being a work of art or craft rather than something everyday and ephemeral. But this is not necessarily so. A handwritten letter to a friend may not be calligraphy, but a simply written notice announcing a forthcoming event could be. Perhaps there is no clear dividing line and we shouldn't be too concerned about definitions.

Calligraphy has undergone a revolution in the last few decades and the old formal concepts are being challenged. Some regard it as an art, and are not concerned that the writing can be read but rather that the works celebrate the curves and linear forms that a pen or brush can make. This is not an excuse

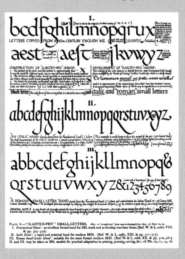

Above Edward Johnston's writing sheet was used as a guide for manuscript and inscriptional lettering for schools.

for bad writing. If the intention is that something is to be read, it should be legible, so legibility is an important element of calligraphy in most situations. However, there is something enjoyable about making marks on paper (or other materials) with a writing instrument like the broad-edged pen, which creates smooth variations in line thickness. We have an inherent liking for these calligraphic marks.

Calligraphy is used for a wide range of applications, from the simple notice to the most elaborate manuscript book and from the names on certificates to the lettering engraved or cut in all sorts of materials. It can be used effectively to personalize or add prestige to documents such as invitations and presentation scrolls. It can be a creative pursuit in its own right.

Calligraphy doesn't require lots of expensive materials. To fully explore the exercises in this book you will need: a bamboo pen for flexibility and a full range of motion when writing; a penholder, complete with reservoir and a selection of steel nibs to allow you to experiment with size; two non-waterproof inks; and, of course, paper.

Writing instruments

ANYTHING THAT CAN MAKE a mark on a surface can create calligraphy and the projects in this book will suggest that you use some rather unusual writing instruments. Of course, the traditional writing instrument is the pen, and the letter shapes of our alphabet have developed through the influence of a particular sort of pen with a broad or chisel-shaped tip.

Pens and nibs

A pen is simply a piece of shaped material that can be held comfortably so that one end can be moved smoothly over a surface. This end

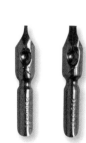

Right Steel nibs come in a variety of sizes and shapes. Note the split that helps ink flow.

part, the nib, is formed so that it will retain ink or other writing pigments up until the moment when it touches the surface, at which point it will release the pigment slowly. If you examine a calligraphy pen, you will see that the nib is split. Bamboo pens, quill pens, edged and pointed dip pens, and fountain pens all require this essential feature to operate effectively. The split has two functions. Firstly, it helps the ink to flow freely to the tip and, secondly, it makes the nib a little bit more flexible.

Note that steel nibs and bamboo pens typically end in a straight edge, not a point. It is this edge that creates thick and thin strokes when you write with the nib at a constant angle. Pulling the nib directly toward you creates the thickest stroke, but in contrast if you move it sideways writes a fine line. When you write a curved shape, it gradually changes from thin to thick and back to thin again. If the nib had a sharp point, the variation in thickness would be determined by pressure only.

Left Quill pens—from Arrighi's *La Operina* (1522).

Above A bamboo pen is useful for writing very free script.

Right A broad-edged pen held correctly will write an elegantly shaped line.

Most dip pens can be fitted with a small tubular reservoir that either clips on just below the nib, or else is permanently attached. Without this, you could write only a letter or two before the ink ran out. With the reservoir and a smaller pen size, you should be able to write many words without refilling. You will find that a bamboo pen requires regular refilling.

There are many other types of pens, such as the "poster pen" and "automatic pen," but all work on the same principle. Even fountain pens that have an ink supply held in a capsule are variations of the same instrument. Experiment with these other pen types.

Writing media

WHEN WE TALK ABOUT writing, we refer to pen and ink, but you can write with pigments other than those that would generally be thought of as ink. Traditionally, black ink was a medium made from carbon (sometimes ground from a "Chinese stick"), which was mixed with water and to which a binding medium was added. Colored inks were made from many different natural materials, depending on the color required. Today, some black inks are still made from a formula similar to that used over the centuries, but more often both black and colored inks include several modern chemical ingredients.

Any ink can be used for practice, although those containing resin (most waterproof inks) will not give such good contrast between the thick and thin strokes and will also tend to clog the pen nib. For finished work, it is best to use a non-waterproof ink.

Above A traditional Chinese ink stick used to make a black pigment.

Choosing color

When you use color you must consider how permanent you want your work to be. Many items that professional calligraphers produce are archival and expected to have a permanence of several hundred years. If your calligraphy is something that will be exposed to light for only a very short time, you need not worry about color change. If you plan to display your calligraphy on a sunny window or wall, many color pigments will fade very quickly, especially reds. For a permanent medium, a mixture of artists' watercolor or gouache, water, and a little gum arabic (used to bind the medium) will produce a good writing pigment. Medieval scribes used egg yolk or egg white as a binding medium and this gave the rather attractive sheen to the colors in old manuscripts.

Above This word was written with waterproof ink. The pen strokes do not start or finish crisply.

Above The same word written with non-waterproof ink. Note the start and end of each pen stroke are much crisper.

Care and storage

Always keep the tops on your ink bottles when not in use. Ink can evaporate quickly. If your ink has become too thick, thin it with a little water. If you live in a hard water area where the water contains chalk or lime, it is better to use distilled water.

Obviously, ink is an essential component of calligraphy, so you might want to invest in some that suit your needs. Remember, this is a highly personal choice: there are many varieties and colors to choose from depending on which type of pen you use.

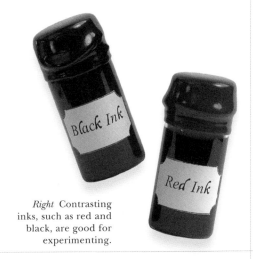

Right Contrasting inks, such as red and black, are good for experimenting.

Writing surfaces

Right A page from the *Lindisfarne Gospels,* illuminated around 698 CE and housed in the British Library.

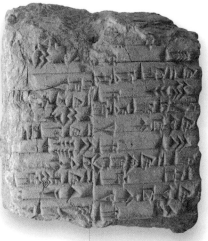

Left A clay cuneiform tablet c. 3000 BCE. The writing was produced using a triangular-shaped stick.

IF YOU CAN WRITE on it, then it is a writing surface. The first scribes, some four thousand years ago in Mesopotamia, impressed their cuneiform letters on clay tablets. The ancient Egyptians wrote their hieroglyphics on papyrus. Medieval scribes wrote on parchment made from sheepskin or vellum, a smooth calfskin. Some calligraphers today use vellum for the most important work.

Below Papyrus was used as a writing surface by some cultures over several thousand years.

Writing on paper

For the last three hundred years or so, the most common writing surface has been paper. It was introduced to the West from China, probably by the Arabs, in the 12th or 13th century. However, only in the 15th century was it widely used for the new printing process and nearly two hundred years passed before it replaced vellum for formal documents.

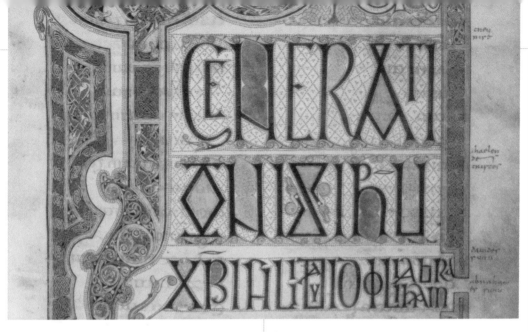

Paper is a wonderful material. It is inexpensive; light in weight; can be produced in any color; can have a textured or smooth surface; and folds well, making it eminently suitable for books. Many white papers (those that are acid-free) will not yellow or stain with age. For calligraphy, paper that has a smooth, rather hard surface is best. The pen will move freely and the ink or other pigment will not spread or bleed. Avoid the coated papers used in the printing trade. When you are practicing, any good, smooth cartridge paper will be adequate. Thin "layout" paper, used by designers, is also a good material to experiment with.

The thinner quality is translucent and can be laid over copies for tracing.

If you are producing calligraphy that you want to keep, it is best to use a smooth mold paper, usually called "hot-pressed." It comes in sheets that have a rough, "deckled" edge. Don't cut off this edge unless you have to, as it can be decorative. These papers are acid-free and will not change color, even when exposed to the brightest light over a long period of time.

Store paper in a dry, dust-free atmosphere. Paper that is kept in humid conditions will distort and can even make the ink or other writing pigment spread over the surface.

From handwriting to calligraphy

THERE IS AN ENORMOUS range of methods by which we are taught handwriting at school and "styles" that we learn to copy. This will depend upon our age and generation, our geographical location, and the fashions at the time. The loose terminology often used is confusing—script, linked script, copperplate, italic, and so on. Few schools teach principles and pupils often have to copy from books or from examples written by the teacher. The quality of that early teaching of handwriting is evident in later life when we find that the stresses of modern living have destroyed what in our youth we considered to be an elegant hand. But the handwriting of many has survived remarkably well, especially if a conscious effort has been made to improve or to learn a style that has a sounder basis than the one originally learned.

Italic style writing

Many people use italic handwriting, or a variant of it (*see next page*). There is even a Society for Italic Handwriting. An italic hand is a very good basis from which to learn calligraphy. Many of the principles are the same and often the letters of the informal script can be developed rapidly into a good calligraphic form. However, even if your handwriting is not italic, we can use it as a basis to learn about letterform.

As an exercise, try using a bamboo pen to write in your own handwriting. Don't make any changes, but make sure that you hold the pen so that the broad edge is at an angle and also that this angle remains constant. You will see that the thicks and thins created by the pen add character to your writing. Some of the basic forms in your handwriting might not be satisfactory, but we will identify these later.

The other thing that you will notice is that it is not as easy to push the pen as it is to pull it. We learn later that calligraphic script is mostly written in pen pulls and numerous pen lifts, rather than in a continuous line, as is the case with handwriting.

Figure a Italic handwriting written with a pencil.

Figure b An informal cursive script written with a pencil.

Figure c The same italic style as in figure a, written with a broad-edged bamboo pen.

Figure d The same script as in figure b, written with a bamboo pen.

Rhythm and pattern

THE RHYTHMIC PATTERN OF calligraphy is the result of vertical and/or sloping lines being repeated over and over again in a parallel fashion. Some writing styles, italic for example, have more than one angled stroke. This has the result of enhancing the regular pattern effect.

Establish your rhythm
Try this exercise. Don't worry too much about technique for now. Using a pencil, write three or four lines in your usual handwriting fairly close together, probably much closer than you would normally write.

Examine the writing carefully. Does it form a rhythmic pattern? If it does not, let us find out why. Look at the letters b, d, g, h, j, k, l, p, and q. Are the lines forming the ascenders and descenders parallel? If not, try writing the lines again, this time concentrating on keeping these lines parallel. Now look at the rest of the vertical sloping lines that form the letters. Are they parallel to each other? If the lines still don't look parallel, then try writing them for a third time, ensuring that these lines are also parallel. Finally, try writing the same lines using your bamboo pen, keeping the broad edge of the tip at

Figure a Handwriting that has a degree of rhythmic pattern.

Figure b Handwriting with verticals and various angles.

the same constant angle. You should discover that the rhythmic pattern in the script is greatly enhanced, simply by using a different writing instrument.

Textural color

A block of text, whether calligraphic or typographic, has its own visual texture, or "textural color." It is remarkable how very slight differences in the individual letters can alter the texture of text. Changes in height to letter weight, width to height proportion, and variation in the thick and thin lines of the letters, serif form, letter space, and line space will alter this "color." Figures d–f illustrate three slightly different roman typefaces. Slight variation in calligraphic form produces similar effects and by contrasting one form with another, these differences can be used to great effect in calligraphy to create interest in the design.

Comme il n'ya point de vuide en nature, non plus'y en a il es choses spirituelles; chaques vaisseau est plein sinon de liqueur, ammoins d'air:

Figure c The same handwriting as in figure b, but with some consideration to the verticals and written with a bamboo pen.

Aa

Having acquired a formal hand the penman may modify and alter it, taking care that the changes are compatible, and that they do not impair its legibility or beauty. Such letters as are obsolete he replaces by legible forms akin to them in feeling, and, the style of the selected type becoming very naturally and almost unconsciously modified by personal use, he at length attains an appropriate and modern Formal-Handwriting.

Aa

Having acquired a formal hand the penman may modify and alter it, taking care that the changes are compatible, and that they do not impair its legibility or beauty. Such letters as are obsolete he replaces by legible forms akin to them in feeling, and, the style of the selected type becoming very naturally and almost unconsciously modified by personal use, he at length attains an appropriate and modern Formal-Handwriting.

Aa

Having acquired a formal hand the penman may modify and alter it, taking care that the changes are compatible, and that they do not impair its legibility or beauty. Such letters as are obsolete he replaces by legible forms akin to them in feeling, and, the style of the selected type becoming very naturally and almost unconsciously modified by personal use, he at length attains an appropriate and modern Formal-Handwriting.

Figures d–f Three slightly different roman typefaces; very slight differences in letterform change the visual texture of text as seen here.

Line and shape

Right The various parts of letters.

By now, you will have realized that there is great importance being placed on the broad-edged pen. The basic shapes of the letters of the Western alphabet have been greatly influenced by this writing tool. Most typefaces owe the variation in thick and thin lines or strokes to the broad-edged pen and most historians believe that serifs (*see page 23*) also derive from it.

Good writing and calligraphy will comprise smoothly flowing lines without any unnatural or awkward angles. Perhaps surprisingly, it is easier to form elegant curves with a broad-edged pen than with a pointed one. But when you write, you must have confidence in your ability to make these smooth marks. Unfortunately, any nervousness will reveal itself instantly.

Below Calligraphy should be written with smoothly flowing lines.

lettera

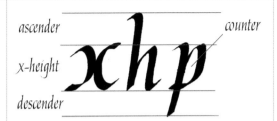

ascender

counter

x-height

descender

Letters are formed from lines. The line that rises above small or lowercase letters (in b, d, h, k, and l) is called the "ascender." The line that drops down below the letter (in g, j, p, q, and y) is called the "descender." The main part of the letter is called the "x-height." The lines that form the letters create shapes, either within the letter, when they are called "counters," or between letters. These shapes are as important as the lines that form them. When you are learning a new calligraphic style, or "hand," examine the counter shapes very carefully. Pay particular attention to the consistency in letters that have similar or complementary counters, a, b, d, and g for example.

The shape formed when two letters are placed together is the letter space. Good letter spacing is essential in calligraphy. In typography, the letter space is mechanically determined for you. With calligraphy, you have the opportunity to vary the space between groups of letters to create the most satisfactory arrangement. Good space between letters does not mean that the physical distance between them is the same. What is important is the visual distance—it must look right. Consider the letter c followed by the letter i, and the letter l followed by the letter i. Because of their shape, there is much more visual space between the c and i than between the l and i. This means that the l and i must be positioned physically further apart than the c and i if they are to look equally spaced.

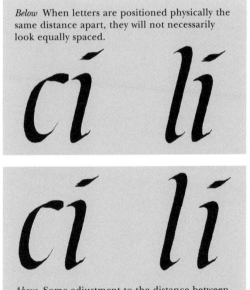

Below When letters are positioned physically the same distance apart, they will not necessarily look equally spaced.

Above Some adjustment to the distance between letters is needed to make them look the same distance apart.

Lessons from the past

THE ANCIENT EGYPTIANS USED three
forms of writing: hieroglyphic, which was
usually carved in stone, and hieratic and
demotic, written on papyrus with a reed pen.
The Romans used four forms of writing: the
well-known inscriptional capitals, written
forms called square capitals, rustic capitals,
and a very informal cursive. Throughout
Medieval times, various writing styles were
employed, including humanist, gothic,
and versal forms. During the Renaissance,
and especially after the development of
printing in the 15th century, scribes wrote
in different calligraphic scripts depending
upon the use to which these were being
put. So we will find formal italic and gothic
forms used in religious documents, secretary
and court hands appeared in legal and civic
documents, and informal cursive writing
used for correspondence.

Today, we have at our disposal a range
of approaches to written communication,
including handwriting for notes and
correspondence, typing or word processing

Figure a Roman rustic
capitals were written with
a very steep pen angle.

Figure b The pen angle
for uncial writing was
almost horizontal.

for correspondence and documentation of all sorts—and, of course calligraphy, for these important pieces where the application of craft or artistic skill is required.

Evidence of the use of the broad-edged pen can be seen in some Egyptian hieratic documents, but it was not until the Romans

Carolingian

Figure c The Carolingian minuscule was the form on which Johnston based his foundation hand.

Italic

Figure d The italic hand was the form used in many of the Renaissance copybooks. It started a handwriting revolution.

used rustic capitals that we see the first truly calligraphic script. Every form that followed—including uncials, half uncial, Carolingian minuscules, gothic, humanist scripts, and italic—was written with a broad-edged pen. It was not until the advent of copybooks that the broad-edge pen was gradually replaced. Scribes now used a very flexible sharp-pointed writing tool and this worked in a very different way. Instead of thick and thin lines coming from the broad edge of the nib, thicks and thins were now created by pressure. This meant that the scribe could thicken the line anywhere, rather than where it should have been according to the historically based form of the letters. Copybooks were produced from engraved copper plates and the engraving tool followed, and often exaggerated the effects produced by the flexible pen.

It was not until the late 19th and early 20th centuries that the broad-edged pen was, in effect, rediscovered through the efforts of a few people, such as the artist William Morris and the calligrapher Edward Johnston. Johnston considered the Carolingian minuscule to be the purest calligraphic style and as a result, he based his foundation hand on it. The foundation or "round hand" that you will learn in this book is a variant of Johnston's hand.

The broad-edged pen

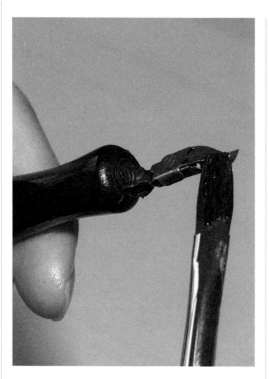

Above The pen should be filled below the nib with a brush to avoid getting ink on the upper surface.

UNLESS YOU HAVE USED a fountain pen with a square- or broad-edged nib, metal-nibbed and bamboo pens will be nothing like anything you have experienced before, and writing with these tools will certainly feel different.

To begin, fit a nib to your penholder and a reservoir to the nib as described on page 9. Your pen should not be dipped. If you dip the pen, you will have ink on the top, as well as the bottom surface of the nib. This will reduce the desirable contrast between the thick and thin strokes of the letters and the overall crispness of the form. Fill the pen with a small, inexpensive artist's brush by applying the ink to the under surface of the nib between the nib and the reservoir. If you must dip the pen, wipe off the surplus on the upper surface.

Except in a few exceptional situations (some free italics), calligraphy with a broad-edged pen is written in pulled strokes. If you find that your pen doesn't write when you form a pulled stroke, push the nib from side

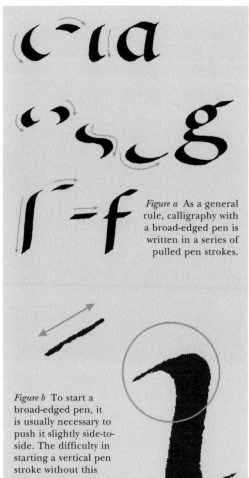

Figure a As a general rule, calligraphy with a broad-edged pen is written in a series of pulled pen strokes.

Figure b To start a broad-edged pen, it is usually necessary to push it slightly side-to-side. The difficulty in starting a vertical pen stroke without this sideways movement probably led to the initial serif in our lowercase alphabet.

to side on a scrap of paper. This should trigger the flow of ink. Indeed, the initial serif on calligraphic letterforms probably originated from the fact that it is difficult to start the pen writing with a straight downward stroke.

If you are left-handed, you may have some initial difficulty with a metal-nibbed pen. Unfortunately, our alphabet is a right-handed one! However, if you devise a way of holding and using it (left-handers differ in the techniques they use) you might find you will become a better calligrapher than many right-handers.

Don't clean your metal nibs after you have used them for the first time. The ink will etch a slight texture on the metal and this will help to retain ink the next time you use it. After the second and subsequent use, wash the nib well with water.

Your bamboo pen shouldn't have a reservoir and consequently it will have to be filled regularly. It is more practical to dip bamboo pens, but if a fine thin stroke is needed, you will have to wipe the top surface. You will find that you can push a bamboo pen much more easily than is the case with metal nibs. This will let you write much more freely but without the "sharpness" achievable with the formal writing tool.

Pen angle, letter weight, and letter proportions

WHEN WE REFER TO pen angle, we mean the angle that the broad edge of the nib makes in relation to the writing line and not the angle at which the writer holds the pen. This angle is critically important in calligraphy, as it determines where the thick and thin strokes appear in the letters. A good exercise that will give you a feel for the effects of writing with a broad-edged nib is to write zigzag and wavy patterns with the pen held at a constant angle. Try to make the pattern as regular as possible.

Pen angle and weight

Different writing styles require different pen angles. As you will see, to write the foundation, or round, hand, the pen angle

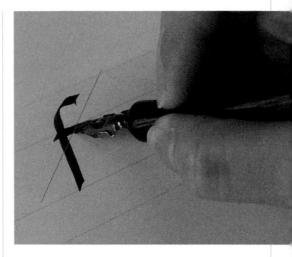

Above Pen angle is the angle that the broad edge of the nib makes with the horizontal writing line.

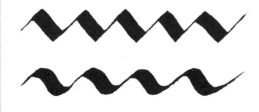

Left Writing zigzag and wavy lines with a broad-edged pen helps to get a "feel" for the thick and thin pen strokes.

is about 30–35°. In the case of italic, the angle is about 40–45°, while the uncial is written with the pen angle almost horizontal. The pen angle affects both the shape of the letters and their weight—that is, the darkness—of the text. Uncial is the heaviest, italic the lightest, and the foundation hand somewhere in between. There is also a relationship between pen angle and the slope of the letters, but we will consider this when we learn the two basic calligraphic styles.

Figure a The horizontal pen angle of the uncial influenced its led to its roundness and rather heavy weight.

Figure b The foundation hand (and roman forms derived from it) has a medium weight and classic proportions.

Figure c Italic writing is narrow and tends to be light in weight.

Letter proportions

There are several aspects of letter proportion that must be considered. Later you may wish to vary the proportions of your scripts. However, it is best to start with a good understanding of the height to width ratios and appreciate the effects of ascenders and descenders. The shape of the small letter o sets the proportions of the other letters of the alphabet. So, if you make the o a perfect circle, as is the case in an uncial form, then the rest of the letters should be very wide. If you make your o tall and elliptical in shape, as is the case in italic, the rest of the letters should be narrow. Of course, all letters are not the same width: we can't make an i the same width as an m! However, there are repetitive shapes in the alphabet that should retain the same width to height proportion, such as the "bowl" of the a, b, d, g, p, and q and the arching shape of the h, n, and u and, in a modified form, the m. Other letter proportions have to be learned. As a rough guide, wider letters have shorter ascenders and descenders than narrow ones.

Preparing to write

Figure b The "correct"
way to hold a pen
(Mercator, 1540).

WE ALL HAVE DEVELOPED our own way of holding a pen, and probably most of us have developed what are technically very bad habits but have found that they work for us. It may be better just to modify the way you write rather than to attempt a radical change. The choice is yours. It is essential, however, that you are able to maintain a constant pen angle and can manipulate the pen freely. A good, comfortable posture is also extremely important.

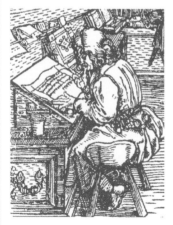

Left A 16th-century scribe at his desk. Note the steep angle of the writing surface.

Benefits of an angled surface

Medieval scribes worked on a writing stand that was angled at about 60° because with the writing surface at such a steep angle, the actual pen was held almost horizontally and the flow of the ink was far more controllable. If the pen was held vertically, the ink ran out much too quickly. Even with a reservoir fitted, modern steel pens used for calligraphy work much better if the writing surface is at an angle. A drawing board can be propped up with books or a wood block.

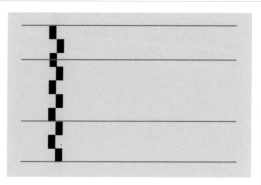

Figure a Mark off the appropriate number of pen widths for the ascender, x-height, and descender to suit the lettering style.

Figure b Ruling of the ascender, x-height, and descender for two lines of calligraphy.

Ruling guidelines

Adding ruled lines lightly in pencil makes it easier to keep your writing in a straight line, and to maintain a constant letter height and regular slope. To get a sense of how straight you write, create a ruled sheet, as demonstrated above, place a thin sheet of paper over it so you can see through, and practice writing on the line. There are different approaches to the ruling of guidelines. Some follow the procedures of the medieval scribes, who ruled only two parallel lines. But it's much easier if you rule the top of the ascender, the top and bottom of the small letters (x-height), and the bottom of the descender, and also rule the approximate slope of the lettering (see diagrams on *pages 28* and *32*). Left and right margins and any column guides should be indicated. Always use a very soft pencil so the lines can be erased easily.

To prepare a sheet of paper, first determine the x-height and the ascender and descender positions by drawing short strokes with the nib held at a vertical pen angle (*figure a*). The number of pen widths will depend on the style of lettering. Mark these positions on the edge of a piece of paper and use this to mark up your final sheet. Repeat this every time you start a new piece of calligraphy. Fix your paper lightly to a smooth, surface by using a narrow strip of paper pinned at either side of the sheet.

The foundation or round hand

LETTER HEIGHT

Ascenders 3 pen widths

x-height 4 pen widths

Descenders 3 pen widths

PEN ANGLE

30–35°

The pen should be held at an angle of 30–35° to horizontal

SLOPE 5°

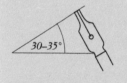

Letters slope 5° to the vertical

THIS SCRIPT FORM IS written in a series of pen strokes with a pen lift in between. However, you should still feel that you are writing the letters rather than drawing them. Prepare your paper using the dimensions given in the chart.

Write some simple lines sloping slightly to the right (this is the 5° slope). Make the lines the x-height, first pushing the pen to the right, then downward and finally to the right and slightly upward (*figure a*). Write another set of lines, this time making them the full height of the ascender (*figure b*). Try to keep the space between each line the same. This is good practice for letter spacing.

Write the letter o a number of times, following the strokes shown in the illustration (*figure c*).

Write the letter n, again following the strokes in the illustration (*figure d*). Note that the second stroke is similar to the first, but the pull to the right at the top of the line is longer. Try to create a very crisp, sharp join between the two lines.

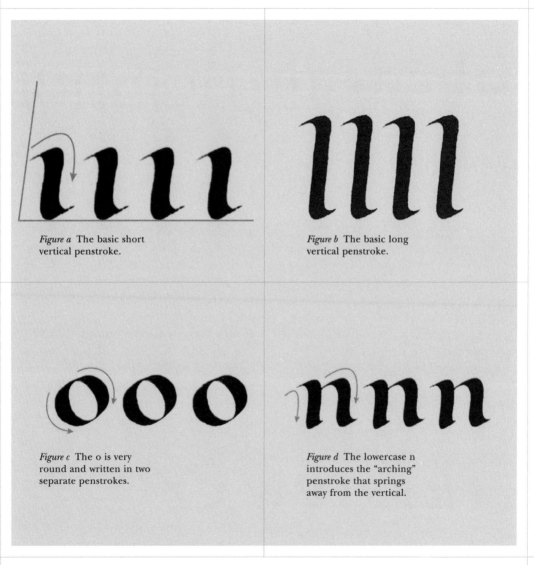

Figure a The basic short vertical penstroke.

Figure b The basic long vertical penstroke.

Figure c The o is very round and written in two separate penstrokes.

Figure d The lowercase n introduces the "arching" penstroke that springs away from the vertical.

abcdeghijmpquy

Figure a Most of the letters of the foundation hand can be written using the basic penstrokes.

Study the letters in figure a. You will see that each one of them can be written using very slight modifications of the pen strokes that you have already learned.

The dots over the i and j are best written with a left to right line rather than a diamond shape, which would be too conspicuous.

The remaining letters of the alphabet (*figure b*) are the odd ones that need special treatment. The letters f and t are easy to write, but do not be tempted to extend the horizontal line much to the left. The letter r should have an exaggerated "serif" at the top to compensate, to some extent, for the space on the right. Write the letter s in three pen strokes, but don't overdo its curvature. With the letters k, v, w, x, and z, we have to break the rules and change to an almost horizontal pen angle as in figure b. Ensure you return the pen to the original angle afterward.

fkrstvwxz

Figure b These letters require some new penstrokes. Note that the pen is turned to a different angle in the k, r, v, w, and z.

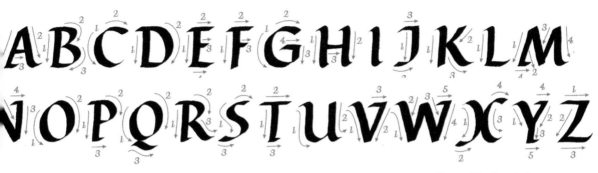

Figure c The foundation hand capitals.

The capital letters are simple roman forms written using pulled pen strokes. We will explore variations of these later.

Don't spend too much time practicing individual letters. It is important that you move on to writing words and sentences so that you build up a rhythm in your calligraphy. This will also enable you to develop an eye for good letter spacing, as explained on pages 18–19.

Figure d The numerals are written in a series of pulled penstrokes.

The italic hand

LETTER HEIGHT

Ascenders 3 pen widths

x-height 5 pen widths

Descenders 5 pen widths

PEN ANGLE

40–45°

The pen should be held at an angle of 40–45° to horizontal

SLOPE

15°

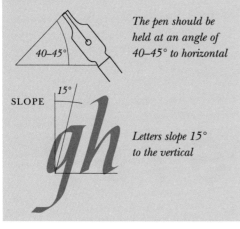

Letters slope 15° to the vertical

WE HAVE SEEN UP to now that a broad-edged pen should be used in a series of pulled, rather than pushed strokes. With the italic hand, the rules will be broken—just a little. An italic script was the first very cursive, formal script. In the later Renaissance period, it was the first form to be recommended as a basis for handwriting as we know it today. You should aim for this free-flowing rhythmic quality of italic while retaining good letterform. You may find it easier to learn italic with a bamboo pen before moving on to metal-nibbed pens.

Start by writing the same letters i, l, o, and n as before. This time, don't lift the pen from the paper, but push it up and to the right while reducing the pressure on the nib. The steeper pen angle and italic slope should make this easier. Resist the temptation to change the pen angle.

Follow the construction method for each letter as illustrated. In the meantime, use the same capitals as shown for the foundation hand, but with a greater slope.

íííí

Figure a The basic italic
vertical penstrokes.

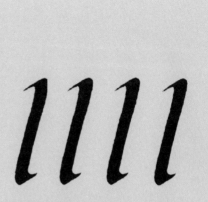

Figure b The basic long
italic penstrokes.

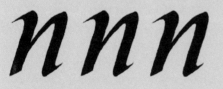

Figure c The italic
arching form springs
from the vertical.

o o o

Figure d The italic o is
quite narrow.

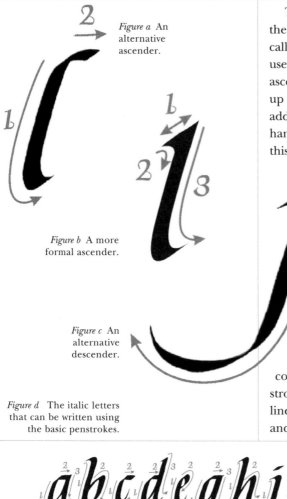

Figure a An alternative ascender.

Figure b A more formal ascender.

Figure c An alternative descender.

Figure d The italic letters that can be written using the basic penstrokes.

There are various ways of writing the ascenders and descenders in italic calligraphy. These can also be adapted for use with other script forms. The simplest ascender form is the one that has been used up to this point (*figure b*). An alternative is to add an additional pen stroke on the right-hand side of the ascender (*figure a*). To do this, begin the ascender with a right to left stroke and complete the form with a left to right line. The terminal line should curve very slightly downward, like a mirrored descender. An alternative to the simple descender is shown in figure c. This form is tricky to construct but is very effective in giving a lively, informal look to italic. Once again, we will break the rules a little. When forming the descender, rotate the pen counterclockwise as you write the curving stroke from right to left. With practice, the line should taper to a thin line, broaden out, and taper once again to a point.

A B C D E F G H I J K L M N O P Q R S T U V W X Y Z

Figure e Simple italic capitals are similar to those of the foundation hand, but are written at a much greater angle.

Figure f Basic italic numerals are the same as those of the foundation hand, but written at the same angle as the rest of the script.

1 2 3 4 5 6 7 8 9

f k r s t v w x z

Figure g The remaining letters of the italic hand.

Variations on a theme

HERE WE WILL CONSIDER applying changes to the basic form consistently throughout the letters of the alphabet to develop a new hand or script. This is different from flourishing, which is the extension of letters of a fixed alphabet design in a decorative way.

The foundation hand is well named. With some basic modifications to the form, it becomes a gothic, or black-letter hand. Indeed, historically this is how this well-known medieval manuscript form evolved, the letters of the Carolingian minuscule becoming narrower, more angular, and heavier as a result. Modifying the foundation hand in another way converts it into a form called uncial.

The italic script lends itself well to embellishment, especially of the ascenders, descenders, and capitals, as well as to changes in proportion.

Gothic

The x-height should be about the same number of pen widths as was the case for the foundation hand (4½), but the ascender and descender can be a little shorter. The letters should be a bit narrower and the slope almost vertical. Start by writing the same letters as you did when you were learning the foundation and italic hands—i, l, o, and n. The pen strokes and pen lifts are identical to those used in the foundation hand, but note the strong angularity of the o and the modified ascender and descender. Write

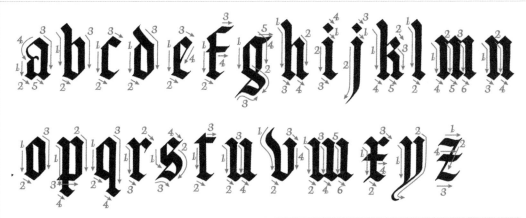

Figure b The construction of the gothic letterforms.

Figure c Gothic capitals are written in a series of pulled penstrokes in the same way as other scripts.

the second group of letters, following the pen strokes as shown. Finally, try writing the rest of the letters of the alphabet. You will see that some of them are slightly different in basic form from those of the foundation hand. Legibility can be a problem with the gothic form. A good illustration of this is to write the word "minimum" which is made up of a series of identical strokes.

Figure d The capitals of some gothic forms have additional hairlines drawn vertically and horizontally.

Figure e Gothic capitals. Note that these capitals contrast with the lowercase by being less angular in form.

𝔒 𝔓 𝔔 𝔕 𝔖 𝔗 𝔘 𝔙 𝔚 𝔛 𝔜 𝔷

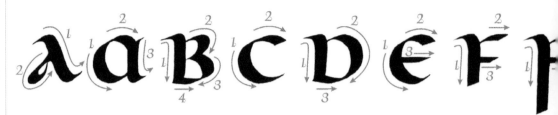

Uncial

The uncial hands, and variants of them, were used in the great manuscripts of the so-called "Dark Ages." The *Book of Kells* and the *Lindisfarne Gospels* were written in a style called half-uncial, where ascenders and descenders can be seen in some of the letters. In the pure uncial hand, there is no distinction between small or lowercase letters and capitals. There are several uncial forms. Here we will write a simple, basic one that can be modified later. As with other calligraphic styles, changes to the serifs and the addition of flourishes can be made once you have mastered the basic form.

A characteristic of the uncial is its roundness. The o is a perfect circle and the other letters are correspondingly wide. It is also fairly heavy in weight, so use an x-height similar to that for the foundation hand, but no greater. The slope is almost vertical and the pen angle very flat. Historically, our minuscules, or lowercase letters, evolved from uncials but it is better to learn the uncial after you have become familiar with the capitals and lowercase foundation alphabets. If you have become competent writing the foundation hand, you should have no difficulty following the construction of the uncial because the vertical, horizontal, left curve and right curve pen strokes are almost identical.

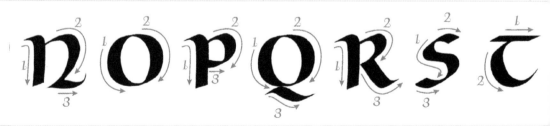

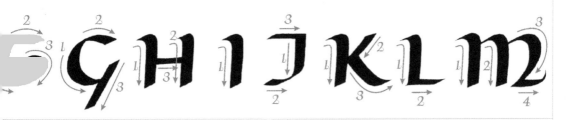

Try developing your own variations of the uncial. An easy way to give it a very different appearance is to make the letter much narrower. The uncial was usually a very carefully written script, but writing it very freely as a much more informal hand changes its character. Uncials can be used very effectively as initial letters, contrasting with other text styles, including round hand or italic.

Uncial can look very nice written in circles. Writing a layout of this sort is described in Project Six (Calligraphy as illustration) on page 66.

Right Uncial used in a circular layout. Calligraphy photo-etched in brass by the author.

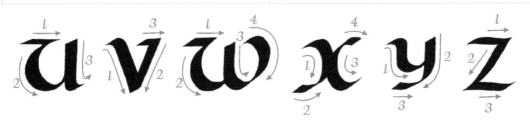

Flourishing

FLOURISHING LETTERS HAS NO obvious practical purpose other than decoration, except where it is desirable to fill a space in a design. Try to avoid adding flourishes which are so complex that they destroy the basic form of the letter. Flourishes should grow from the letter and shouldn't look like something that has just been added on. Some scripts lend themselves better to flourishing than others. Italic and gothic forms are much better than uncial or more formal roman (formalized round hand). We will give additional examples of flourishes in Project One (*pages 40–41*). Here we will introduce some basic ideas.

When you construct a flourish, ensure that you write it in the same way as you did the letter by keeping the pen angle the same throughout and using pen lifts where appropriate. Try some of the exercises illustrated. These are basic flourishes that can be used with ascenders and descenders. Write them first using a bamboo pen and without pen lifts so that you get a feeling

for the flow of the flourish. It is very important that you write with confidence and without any hesitation so that you create smooth, elegant curves. Don't worry if you don't get them right the first few times. Also, make sure that you lift the pen cleanly at the end of each stroke. When you have developed some confidence, try writing them with a metal-nibbed pen, but with pen lifts as shown. This will be a little bit more difficult because you will be tempted to push the pen. Be careful to ensure that each pen stroke is joined as seamlessly as possible.

Many capitals in the italic hand can be flourished. Write the ones in the illustration on the next page and then develop your own.

In the above examples, we have assumed that the flourish is part of the letter. However, it can also be a decorative element in its own right. If you are using a flourish in this way, the same principles apply—that is, you should create the flourish by keeping the same pen angle and giving it a character which is similar to that of the lettering.

Left Some examples of flourished capitals. With a few exceptions, the pen angle is kept the same throughout the construction of the letters.

About the projects

Above Lord of the Dance calligraphy with raised gilding by Maureen Sullivan. Text reproduced by permission of Sydney Carter.

THE FOLLOWING PROJECTS WILL give you the opportunity to put into practice many of the techniques and procedures that you have learned. They are the sorts of tasks that you will be asked to do when your friends or colleagues find out that you have developed some calligraphic skill. They are varied and include formal as well as very free script. They demand little more by way of equipment or material than the pens and paper that you already have. The final project is a brief for which you can design your own solution.

When you have completed the projects, find more of your own. The best way to develop your skills further, and to expand your range of calligraphic styles and tasks, is to look at examples in the books listed in the bibliography. In particular, take inspiration from contemporary calligraphy, which ranges from very formal applied lettering to fine art. Note also how calligraphy is used for traditional applications such as presentation scrolls, manuscript books, and framed decorative panels, as well as being used in very novel ways on glass, wood, stone, and many other materials.

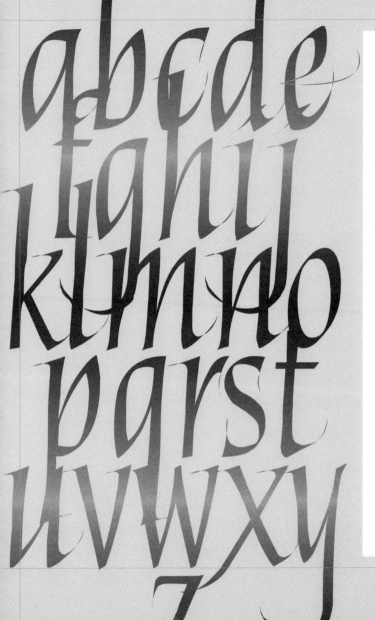

HOW TO FOLLOW THE INSTRUCTIONS

Each project gives step-by-step instructions that can be followed exactly as written. The recommended writing instruments, pigment, color, and paper are listed. The lettering style can be copied exactly as illustrated. However, you will learn much more if you treat the instructions as guidance on basic principles and modify them to suit your own needs or preferences. You might wish to change the texts given or the size of the finished piece.

In most of the projects, you are encouraged to experiment with different writing instruments and even to write with bits of wood or card, which you probably never considered to be pens! However free and experimental your lettering might be, it is important that the basic forms produced by writing with a square-edged instrument are retained.

Above all, have fun with the pen. Calligraphy should be enjoyable and not a chore. The pleasure of making calligraphic marks on a writing surface should be evident in your script.

PROJECT ONE

A calligraphic finish

A SQUARE-EDGED PEN is a very effective instrument for creating decorative designs that coordinate well with calligraphy, because the thicks and thins of the penstrokes match those in the lettering. A calligraphic layout can be spoiled by overelaborate illustrative decoration. However, the use of a small, carefully designed abstract form at the end of the text can complete an arrangement very nicely. This project will give you some experience in creating such a design using a square-edged pen. It will also help you develop your pen skills, as it involves the tricky technique of writing several lines parallel to each other.

GEWÖHNLICH GLAUBT DER MENSCH
WENN ER NUR WORTE HÖRT
ES MÜSSE SICH DABEI DOCH
AUCH WAS DENKEN LASSEN

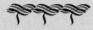

Writing vertical and horizontal parallel lines

1 *Start by writing a simple left to right curving line rather like a flattened letter l. Use any of your writing instruments for this—you might find your bamboo pen best. When you are confident you can write a good, balanced form, write two similar lines parallel to each other. If you write the second line above the first, it will have to start to the right of it. If you write it below, it will start to the left. Finally, try writing three lines parallel to each other.*

2 *Now try doing the same three exercises but this time using vertical penstrokes. Even though you are not using letterforms, try to feel that you are writing with the pen, using well-controlled, smooth strokes.*

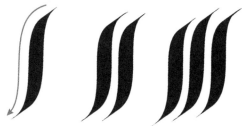

5 Write a second group of three lines parallel to the first, positioning each line where they fit best. Add a third set of lines in the same way. The vertical lines can start and end with or without overlapping the horizontals. These are all the basic skills you need to create the finishing piece.

3 We will now add a second line to these simple forms. Write two penstrokes without lifting the pen, to form a shape rather like a capital L. This time, you will have to write the duplicate form a little above and to the right of the first. Add a third form, again above and to the right.

4 Writing this form without a pen lift is rather limiting. By keeping the elements separate, we can position them where they work best. To do this, we will use the basic strokes learned from steps 1 and 2. Write three penstrokes—two horizontal and one vertical, as in the illustration. This could be an italic capital I.

Calligraphy has been likened to music. Certainly, the pleasure that comes from writing abstract flourishes with a square-edged pen may be similar to the enjoyment that musicians get from playing their instruments. We have already introduced flourishes, but here we will begin to use flourishes in an abstract way to create a visually interesting design.

Designing and using the end piece

6 *We will develop some of the flowing horizontal lines into a flourish. As you already have worked with flourishes, this should be easy. Write a double flourish. Try writing it using both penstrokes and also using a single, continuous movement. If you like, you can use the pen turning technique described earlier in the book (see page 34).*

7 *Write the same form parallel to the first, but on this occasion, pick a color and use it for the second shape, having made sure that the black ink is dry.*

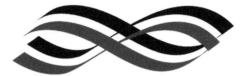

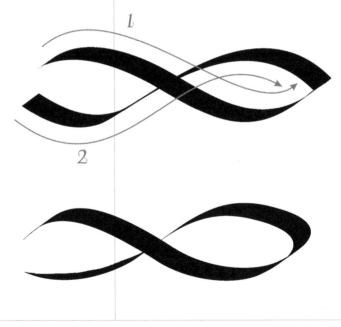

8 When the colored ink (or watercolor) is dry, write a third parallel form in black. This time, write the lower line in two separate penstrokes, writing a vertical curved flourish as shown in the illustration. Don't be tempted to be overambitious with this terminal line—restraint is important!

9 Repeating shapes of this sort can often be effective. Try writing several side by side so that they make a continuous border. This will take some practice but when you can do it successfully, you can be proud that you have achieved some considerable skill with a calligraphic pen.

GEWOHNLICH GLAUBT DER MENSCH
WENN ER NUR WORTE HORT
ES MÜSSE SICH DABEI DOCH
AUCH WAS DENKEN LASSEN

PROJECT TWO

A monogram

DESIGNING A MONOGRAM HELPS you to see the relationship between letterforms. When you have worked through this project, design a monogram using the initial letters of your name. If you wish, you could use it on correspondence or anywhere elsewhere you want to leave your identifying mark. Monograms are formed by joining two or more letters together to make a new single design or symbol. Joining the letters of our alphabet to make a single character goes back more than two thousand years. The Romans used these "ligatures" in their inscriptions and they can also be seen on many tombstones of the 16th, 17th, and 18th centuries. Before designing a monogram, we will first look at different ways of placing and linking letters together.

Above Ligatures are found on early tombstones, like this one from Dundrennan Abbey, Scotland.

Joining letters together

1 *The simplest way to join letters together is to place them close together so that they touch, with only minor modification to the letterforms. Write the letter pairs EH, TA, and TW as shown in the illustration. Then try some of your own. Examine what works and what doesn't work. Experiment with making one letter larger than the other or even using a different pen size.*

2 *If the letters overlap, they create new shapes. Write pairs of letters and look for these new shapes. See also how some of the penstrokes of the letters come together very awkwardly while others make much more elegant combination forms. Look for pattern and rhythm in the joined letters.*

4 *You can also make use of the repeat technique described in Project One where lines are written parallel to each other. It may be necessary to place the letters quite far apart to avoid confusing shapes and lines. Color can be used here, if necessary, to differentiate the different letterforms.*

3 *Another way to join letters together is to create a "ligature" where a part of one letter forms a part of another. The masons who cut the inscriptions on early tombstones were highly inventive in making combinations of letters. Try writing letters together in this way. If it is difficult to make out the individual letters of the ligature, one of them can be picked out in color.*

49

To give you some experience of writing a monogram, we will initially work on one based on the word "AND." The traditional way of representing "and" in a shorthand form is, of course the ampersand (&) that derives from the Latin "et." Some ampersands are very attractive and fun to write with a square-edged pen. Try writing a few yourself. Once you have completed the prescribed project, create a monogram from your own initials or for someone else.

Designing the monogram

5 *You will find it helpful to sketch the monogram in pencil first. The basic shape of the letters and their flourishes is a complex one. It is very easy to get lost while you are writing it. Start with the initial penstroke of the A, then the left-hand flourish and so on, until you have completed the first letter.*

6 *The first stroke of the N is formed from the final stroke of the A that you have already written. Write the rest of the N. Remember that you should write the letters in a series of separate penstrokes with pen lifts in between. Although you are creating a new design from the three letters, in this example it is best if they are the same height and width.*

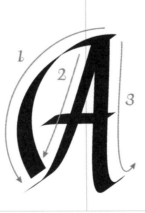

7 *Write the flourish on the N. This also represents the D of AND and should be written in two separate penstrokes. Try to form a perfect circle with the flourishes on the A and ND. Note also the location of the first stroke of the A between the two flourishes and how the start of the D just touches the second stroke of the N.*

8 *Now for the really hard bit! Using two penstrokes, write a circle outside the completed shape that you have just written, keeping the lines parallel to each other. If you find this impossible, you can just stop at stage 3. Try writing the design using two colors. Now design a monogram for yourself.*

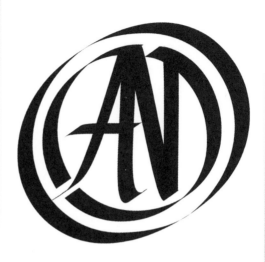

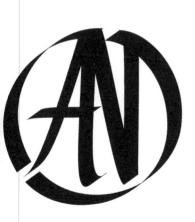

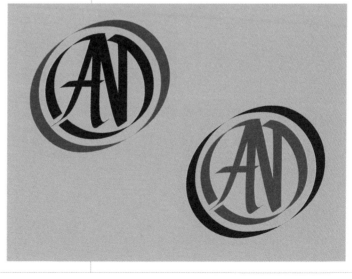

PROJECT THREE
A *bookplate*

A BOOKPLATE CAN BE either a general design with a space for the name or, as in this case, designed for one person. Its purpose is to identify the owner and so multiple reproductions will usually be needed. This project example will be a simple, classic design. Assuming that you have more than one book, it is obviously not practical to write each bookplate by hand and a means of reproduction will have to be considered. This could involve using a scanner, computer, and printer, color photocopying, or perhaps even the more expensive alternative of commercial printing.

1 Using a pencil, sketch a number of different ideas. You might find it helpful to make notes alongside your sketches because this can help you work toward a good solution. Try to represent different sizes and weights.

Lisa - this - weight at top
also line square dot.
Strong clear design + wd
revere ont well

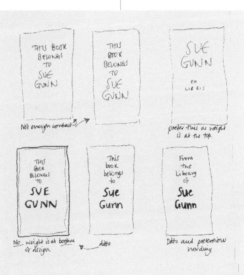

THIS BOOK
BELONGS
TO
SUE
GUNN

THIS
BOOK
BELONGS
TO
SUE
GUNN

SUE
GUNN
•
EX
LIBRIS

Not enough contrast →

prefer this as weight
is at the top.

THIS
BOOK
BELONGS
TO
SUE
GUNN

This
book
belongs
to
Sue
Gunn

From
the
Library
of
Sue
Gunn

No - weight is at bottom
of design. → ditto

Ditto and pretentious
wording

OK but prefer caps

2 When you think you are getting closer to a good idea, sketch it a little larger and more accurately but still using a pencil so that you are not too concerned about the actual techniques of calligraphy at this point. Concentrate on the design.

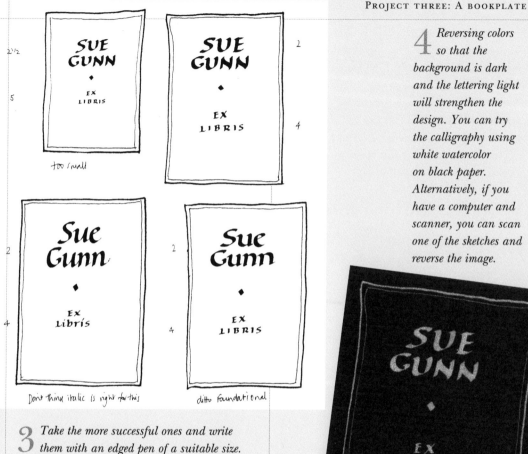

4 Reversing colors so that the background is dark and the lettering light will strengthen the design. You can try the calligraphy using white watercolor on black paper. Alternatively, if you have a computer and scanner, you can scan one of the sketches and reverse the image.

3 Take the more successful ones and write them with an edged pen of a suitable size. Try different styles, sizes, weights, placement, and decoration. Experiment with capitals and lowercase forms. The most important information is the name, so this will be placed at the top in larger, heavier letters than the words "EX LIBRIS" below.

53

You will see from these projects that it is very helpful to produce a mock-up of a design, using separate bits of the calligraphy. This can serve two purposes. It can be used to get a very clear idea of the layout and the use of scale, style, color, etc. at full size. It can also be used, as in this case, as a means of producing artwork that will be scanned or photographed for reproduction.

Assembling the final design

5 *Write out the text several times. Select the best attempts and cut them out. On another piece of the same paper, lay them out until you are completely happy with the design. If necessary, rule lines in pencil to guide you—they can be rubbed out later. Use repositionable glue so that you can move the little bits of paper about easily.*

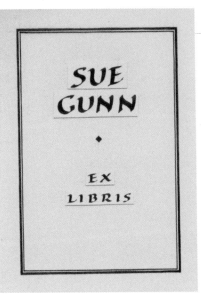

6 *You can draw an irregular two-line border similar to those in the sketches, using a small size pen and black ink. If you want a more formal look, however, the lines should be drawn using a technical pen and ruler. If you make any mistakes— for example, if you overshoot the corners of your border—they can be corrected with white watercolor. If you have the computer facilities mentioned above, you can continue to the next step or take your design to a commercial printer for reproduction.*

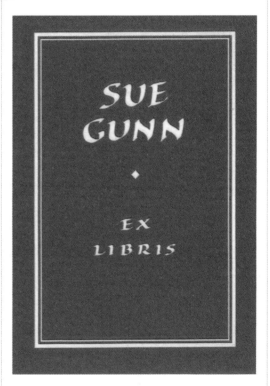

7 *We will assume that the design will have white lettering on a black or colored background. Ideas for color can come from anywhere, so look around and find something that is a color you like and which will suit the bookplate.*

8 *Using a scanner, scan the artwork that you have produced through the above steps. It is a simple process with computer graphics software to invert the colors so that the lettering is white on the darker background. The bookplate can then be printed, several on one sheet of paper, on a laser or inkjet printer. Mark the position of the trimming before you scan the artwork.*

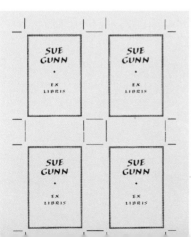

Above A well-positioned book plate can make the volume look very impressive.

PROJECT FOUR

A poster for a "Grande Fête"

MANY PEOPLE LOVE A poster in handwritten calligraphy, even if it is just an informal notice. Many commercial posters use hand-drawn or calligraphic lettering as part of the design. Here we will utilize three sizes of lettering, one of which will be large and used graphically for visual effect. In this design, the word "Fête" (party) will be used as a dominant part of the design, so the calligraphy for it will be explored first.

The main calligraphic element—Fête

1 *Write the word very freely many times using a range of writing instruments, such as metal and bamboo pens. Try using some unconventional "pens." Cut a piece of wood so that it has a writing edge like a square edged pen, but about ¾ inch across. Try writing with the edge of a piece of card stock, or felt.*
You will find that you have to "refill" these tools much more often (possibly every stroke) than is the case with traditional pens, but they will give you the opportunity to write on a much larger scale than is possible with more traditional instruments. For this stage of the design, you can use black ink, as we will be choosing color later. Use a range of styles, including italic, foundation, and uncial as well as variants of them. Try to write so that the letters are quite tightly spaced. This will produce a much better overall word shape. Choose one of the words that has a good overall appearance.

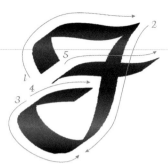

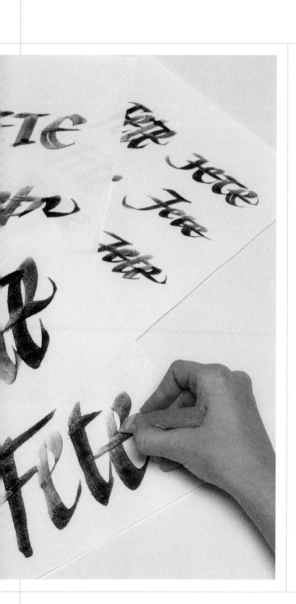

2 *For this example, we will choose a design with a flourished capital F written using the pen made from a piece of wood. This will give us the large scale that is needed for the poster. Write the large capital F carefully, but still very freely. The flourish at the beginning can be written with a pushed or a pulled penstroke. The rest of the letter should be written using pulled penstrokes.*

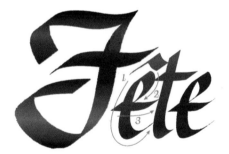

3 *Write the rest of the word in a free italic, using the cut wood or card "pen" cut to a slightly smaller size. Practice writing the word in the chosen style until you are confident that you can reproduce it on your poster.*

Using variation in scale can create visual impact. If lettering is the same size throughout, and especially if there are many words in the design, it isn't easy to grasp the important part of the message quickly. Selecting one or two words that are key to the message immediately conveys what the poster is about. In this case, by making the word "Fête" very much larger than the rest of the text, the message is instantly clear. If the word is visually interesting in addition, then the observer might be encouraged to read the rest of the information on the poster. By making the word calligraphic and very free in form, we hope to make it interesting enough to attract and hold attention.The rest of the text should not compete and can be much smaller and simpler.

Planning the layout

4 *Sketch some ideas as small pencil "thumbnails." Use the large word "Fête" as the starting point and plan the rest of the text around it. You don't have to be very precise at this stage, but be aware of the amount of text that has to be written on the poster and how it will break up into lines. Divide the lines into a logical sequence. We will choose the design with the word "Grande" above the word "Fête" and the rest of the text below. From your sketches, you should be able to estimate the final sizes of the other lettering.*

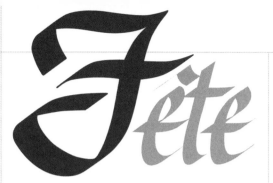

7 Cut these into separate pieces and paste them and the word "Fête" onto a sheet of paper the size of the poster and in the positions you have designed in your thumbnail sketch. Make any adjustments to position or scale.

5 Even more impact can be created if the dominant word is in a different color from the rest of the text. If you have access to colored inks or even poster paints you can experiment with a range of colors by mixing your own. Color will be used only in the word "Fête."

6 The layout will be very simple, each line starting at the same left-hand position and with an uneven right-hand margin ("ragged right"). Using a large size steel pen and a simple calligraphic style based on the foundation hand or italic, write out the rest of the text on practice paper. Make the ascenders and descenders simple and rather formal. Use black ink and the overall effect will contrast with the freely written word "Fête."

Grande

Vendredi 9 Avril

2003

rue de Fleury

Fontainebleau

Commercially printed posters are produced from artwork supplied by designers and do not have some of the restrictions that are inevitable in the case of handwritten ones. Although it is suggested that larger lettering can be produced using pens made from wood, card, and felt, these are usually only suitable for very free and informal calligraphy. One-off hand-produced calligraphic posters are usually restricted to 8 x 11½ inches in dimension or, larger. Of course, a smaller design can be photocopied up to a larger size, even in color. Using the pens suggested— that is, about an inch of wood or card "pen" and a large metal nib—will be suitable for an 8 x 11½ or 11¾ x 16½ inch size design.

The finished poster

8 *Using a paste-up sheet as a guide, carefully rule up your sheet of paper that is to be used for the poster lightly in pencil. It is best to copy the sizes first onto the straight edge of a scrap piece of paper, then transfer these to the final sheet. This saves having to copy them again if you are producing several posters. The guidelines should include at least the usual ascenders, x-height, descenders, and left margin position. Additional guidelines can be drawn if you think these would be helpful (i.e. slope).*

9 *It is best to start by writing the word "Fête" in the free script that you have practiced. If something goes wrong, it won't take nearly so much time to rewrite it than would be the case with the rest of the text. Lightly indicate the position of the word in pencil before you write it.*

Right Calligraphic posters make eye-catching designs in shop windows.

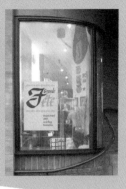

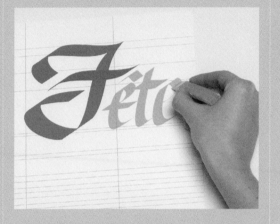

10 *Ensure that the ink/color of the word "Fête" is dry, as you will be resting your hand on it to write the word "Grande"! Write the rest of the text in black ink using the pen sizes that you used for the paste-up. Adding a horizontal border of lettering above and below the word "Fête" can enhance the design. As with some of the other projects, colored paper can be used instead of white. Don't choose a color that is too dark for the poster. Also, check that the paper is not so absorbent that the ink spreads.*

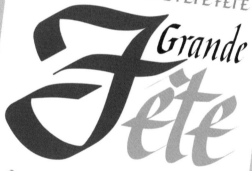

FÊTE FÊTE FÊTE FÊTE FÊTE FÊTE

Grande

Fête

FÊTE FÊTE FÊTE FÊTE FÊTE FÊTE

Vendredi 9 Avril 2003 rue de Fleury Fontainebleau

PROJECT FIVE

A *wedding invitation*

THIS WEDDING INVITATION CAN be adapted for any occasion—for example, an invitation to a party or a reception— by changing the text and choosing an appropriate design for the cover. When you design something that you plan to send through the mail, make sure that you choose a size that will fit into a standard envelope or at least an envelope that will fit. The artwork in this design will be produced at 8 x 11½ inch size for reduction to 6 x 8¼ inch and folded in half. The centered italic layout gives a formal and elegant impression. Good black-and-white photocopying is perfectly adequate for cards such as this. In this example, the cover is elaborate and each individual card would take time to produce so it is suitable only if small numbers are required. However, a simple black-and-white calligraphic cover could be used instead and copied in the same way as the main text.

1 *The calligraphy will be a classic centered layout on a single page. Sketch out the design, giving emphasis to the text by deciding on the hierarchy of information, from the most important words to the least. Here the names are larger and heavier while the reply address is smaller and in a different style.*

se complacen en invitar a S

de Ntra. Sra. de Las Mercedes, Valencia 4

Ntra. Sra. de las Mercedes, Valencia 4½ c

ría Fernández Sánchez 3a

la Sra Farnborough 2½ b

cen en invitar a

matrimonial de su hija con

á lugar 4½ c

o 5 de junio a la una tarde en

de Ntra. Sra. de las Mercedes Valencia

a que se servirá, seguidamente, en

alencia **con** Patricia 3a

ría Fernández Sánchez 3a

a Sra Brown

RESPONDER A

7 · E-46780 VALENCIA · ESPAÑA

Sra. Brown

la Sra. Farnborough

2 Try out different letter sizes and weights on good quality, smooth paper. If you are using different pens, it can be helpful to keep notes, so that you don't lose track of the sizes you have used. This can avoid simple mistakes at a later stage.

3 Cut the text into strips, then arrange the design and paste them in position on a piece of 8 x 11½ inch size paper. Don't worry about the lines being absolutely straight or evenly spaced at this stage. Include a guest's name to ensure that enough room is left for them to be inserted when copied. Mark measurements such as baseline and length of lines on your paste-up, adjusting line spaces when measuring, so they are evenly spaced. When fitting text into a predetermined shape, compromises have to be made in the layout and design. Here, the reduced side margins caused by the long lines are less than ideal.

line length

Baseline

El Sr. y la Sra. Brown

se complacen en invitar a

El Sr. y la Sra. Farnborough

al enlace matrimonial de su hija

Patricia

con

D. José María Fernández Sánchez

que tendrá lugar

el próximo 5 de junio a la una tarde en

La Basílica de Ntra. Sra. de las Mercedes Valencia

y a la cena que se servirá, seguidamente, en

El Oasis, Valencia

SE RUEGA RESPONDER A

C/CALEJO, 7 · E-46780 VALENCIA · ESPAÑA

El Sr. y la Sra. Brown
se complacen en invitar a

al enlace matrimonial de su hija

Patricia
con
D. José María Fernández Sánchez

que tendrá lugar
el próximo 5 de junio a la una tarde en
La Basílica de Ntra. Sra de las Mercedes Valencia
y a la cena que se servirá, seguidamente, en
El Oasis, Valencia

SE RUEGA RESPONDER A
C/CALEJO, 7 · E-46780 VALENCIA · ESPAÑA

5 Photocopy the calligraphy onto a paper that can be written on and that complements the cover. Choose the nib sizes for the names, then rule up and write them on each card. Trim your insert sheets so that they are slightly smaller than the card—make allowance for this at the design stage. Fold each sheet exactly in half and apply a narrow strip of glue along the back of the insert, just in from the fold, then fix in position on the card.

4 Rule up a piece of good 8 x 11½ inch sized paper so that the design sits on the right-hand side. This will ensure that the text is in the right place on the photocopies. Write the text. Remember to omit the guest's name (these will be added individually later) and erase lines and marks that might reproduce on the copies.

El Sr. y la Sra. Brown
se complacen en invitar a

El Sr. y la Sra. Farnborough

al enlace matrimonial de su hija

Patricia
con
D. José María Fernández Sánchez

que tendrá lugar
el próximo 5 de junio a la una tarde en
La Basílica de Ntra. Sra de las Mercedes Valencia
y a la cena que se servirá, seguidamente, en
El Oasis, Valencia

SE RUEGA RESPONDER A
C/CALEJO, 7 · E-46780 VALENCIA · ESPAÑA

7 *The tissue on the front is given deckle edges by folding and dampening the crease before gently teasing the paper apart. Use a water-based glue that dries invisibly (i.e. white polyvinyl acetate—PVA), but remember dyes in exotic, colored papers are very water-soluble and can cause staining in parts of the design. Perhaps you can find a way of using this to good effect!*

6 *The base cover should be made from a good-quality card that is stiff enough to stand when folding in half. Here we illustrate a cover made with the addition of a collage of two other papers and a small artificial flower. Using two textural papers of this sort is an easy way to create an interesting cover effect. What you place on top depends on the nature of the card—be creative with it and devise your own design! In this example, the two papers are purple Khadi Nepalese Mountain paper and white Japanese lace paper.*

PROJECT SIX
Calligraphy as illustration

CALLIGRAPHIC ILLUSTRATION IS drawing made by the same pen that is used for writing and has a similar quality to the script. In the late 17th and early 18th century, the master penmen enjoyed decorating their copybooks with drawings of birds, fish, figures, and imaginary creatures. However, at that time the pen used was a pointed, very flexible quill and the thick and thin strokes were produced by pressure on the pen. Square-edged nibs work quite differently and can produce illustration that works well with calligraphy. Various types of illustration can be used with calligraphy, especially if the medium is the same. Linear ink or watercolor drawings sit well with calligraphy but photographs do not.

Drawing with a square-edged pen

1 *It is not difficult to draw simple shapes with a square-edged pen. It is important that you keep the pen at a constant angle. If the calligraphic illustration is to appear alongside your calligraphy, this angle should be the same as the pen angle used for the script. Draw some simple shapes with bamboo or metal-nibbed pens. You may find it helpful to sketch the illustration in pencil first.*

2 *Now try a more complex drawing. Look at the illustration of the fish. It has been drawn with a sharp pointed quill pen and the thicks and thins are not where they would occur if it had been drawn with a square-edged pen. Copy the illustration using a metal-nibbed pen. Keep the pen angle constant and use pull strokes and pen lifts (practice them first if you like). You may find it easier to write on thin paper placed over the illustration so you can see it below. Don't trace directly from the book because ink may bleed through and damage it. Work from a photocopy.*

3 *When you feel you can draw freely with a square-edged pen, try some drawings of your own. If you work from a drawing or tracing and keep the pen at a constant angle, you can't go wrong. You may find that you can use this type of illustration with your calligraphy.*

Calligraphic images do not have to be figurative or representational. They can be abstract, using letters to create pictures entirely through the juxtaposition of the lines and shapes. Of course, calligraphic letterforms can be arranged into the shapes of recognizable objects. Here we will use two other ways of using calligraphy to create imagery. Some of the examples use the alphabet rather than words, but you can replace this with text if you prefer.

Image-making with calligraphy

1 *In this next example, color will be used. You can either use two colors, such as black and red as demonstrated here, or mix your own from watercolor or colored inks. In the beginning, it is best to limit yourself to two colors together with their intermediates—black and red will make a range of browns. In pencil, sketch out a design based simply on overlapping letters. Rearrange letters until you are happy with the effect.*

2 *Think about the colors that you intend to use. Aim for an overall balance of color and tone. Remember that reds look closer to the viewer than black. Decide on the order in which you will write the letters. The ones you write last will overlap the ones below. Make sure that the letter below is dry before you overwrite it with another color. Try your own ideas, experiment with changing sizes as well as colors.*

est bibendum nunc est bibendum nunc est bibendum nunc est
dum nunc est bibendum nunc est bibendum nunc est bibendum
est bibendum nunc est bibendum nunc est bibendum nunc est
dum nunc est bibendum nunc est bibendum nunc est bibendum
est bibendum nunc est bibendum nunc est bibendum nunc est
dum nunc est bibendum nunc est bibendum nunc est bibendum
est bibendum nunc est bibendum nunc est bibendum nunc est
dum nunc est bibendum nunc est bibendum nunc est bibendum
est bibendum nunc est bibendum nunc est bibendum nunc est
dum nunc est bibendum nunc est bibendum nunc est bibendum
est bibendum nunc est bibendum nunc est bibendum nunc est
dum nunc est bibendum nunc est bibendum nunc est bibendum
est bibendum nunc est bibendum nunc est bibendum nunc est
dum nunc est bibendum nunc est bibendum nunc est bibendum
est bibendum nunc est bibendum nunc est bibendum nunc est
dum nunc est bibendum nunc est bibendum nunc est bibendum

1 *Illustrative elements in calligraphy can be created by picking out a shape in a different color or colors. This can be done by first sketching the illustration on the paper and changing color to reveal the image as you write—a tricky process that requires some practice. An easier way is to use a paper mask. For this part of the project, a simple rectangular layout with rather solid, dark text is best. A gothic form is a good choice.*

2 *Using a piece of inexpensive paper the same size as the sheet you will use for your finished calligraphy, cut out the shape you would like to be part of your design. Keep both the cut-out and the rest of the paper—both will be used.*

3 *Position the cut-out shape in the desired position on the good paper. Fix it very lightly with two small pieces of masking tape or removable glue. Write your text on both your good paper and over the paper mask. Remove the paper mask and any residual glue and the shape will be revealed in white.*

nunc est bibendum nunc est bibendum nunc est bibendum nunc est
bibendum nunc est bibendum nunc est bibendum nunc est bibendum
nunc est bibendum n est bibendum nunc est
bibendum nunc est b dum nunc est bibendum
nunc est bibendum est bibendum nunc est
bibendum nunc est b dum nunc est bibendum
nunc est bibendum est bibendum nunc est
bibendum nunc est bib idum nunc est bibendum
nunc est bibendum nunc est dum nunc est bibendum nunc est
bibendum nunc est bibendum m ic est bibendum nunc est bibendum
nunc est bibendum nunc est bib ndum nunc est bibendum nunc est
bibendum nunc est bibendum m ic est bibendum nunc est bibendum
nunc est bibendum nunc est bi' dum nunc est bibendum nunc est
bibendum nunc est bibendum ir bibendum nunc est bibendum
nunc est bibendum nunc est bibendum ic est bibendum nunc est
bibendum nunc est bibendum nunc est bibendum nunc est bibendum

4 *Position the paper from which you cut the shape over the calligraphy so that only the white shape can be seen through it. Write the missing text in a different color from that used first. Remove the second mask. The shape will now be in a color on a differently colored background.*

This final piece makes use of some of the approaches that you just explored, together with guidance on writing calligraphy in a circular design. The end product is a finished piece of calligraphy. You will discover the rich textural effect of drawing with calligraphy. Although this design is based on a relatively simple flower shape, the same methods and techniques can be adapted for a wide range of applications.

A calligraphic flower

1 Begin by lightly drawing the shape of a flower head in pencil on a piece of practice paper. A symmetrical pattern with an even number of petals will be the easiest to construct, as it will be based on right angles. The design will have to be large enough so that the smallest lettering can be written with your smallest pen size. An overall diameter of 12–14 inches (30–35 cm) would be ideal.

2 Choose a lettering style and pen size to use for the outline of the petals and write the letters of the alphabet, starting with the letter "a" at the tip of the petal and stopping just before you reach the center. Use either capitals or lowercase letters. Try to keep the letters the same size throughout. As you draw each petal, rotate the flower head so that you are writing from the top to the bottom.

3 The pen size may need some adjustments. Cut a disk of paper that will cover most of the center of the flower head. Draw the petals again lightly in pencil on the paper for the finished piece and fix the paper disk in position as a mask. Write the letters of the petal again.

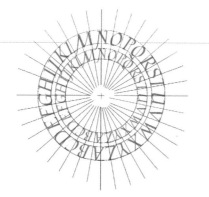

6 Mark up your good paper in pencil with the circles and radiating guide, and write the alphabets in the two concentric circles. Use a different color from the one you used for the petals. Complete the design by drawing a solid circle, either in the same color as the circular alphabets or in another suitable color.

4 Remove the mask. On a piece of practice paper, draw four circular and a number of radiating guidelines, the outer one the same diameter as the paper mask. Sketch in the letters of the alphabet around the two circles. Make the letters of the inner circle smaller. You can either make them narrower or wider so that the whole A to Z fits, or stop when the circles are completed.

5 Write the letters around the circle using a pen of a suitable size (study the illustration). This is much easier than you might think, provided you rotate the paper as you write. You may have to make several attempts before you get everything to fit well.

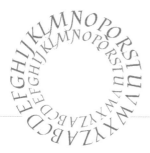

PROJECT SEVEN

A *decorative alphabet*

IN THIS FIRST PROJECT we will design a calligraphic alphabet. Calligraphers enjoy working with our twenty-six letters, either as an exercise or even to develop these alphabets into script typefaces. Alphabets can also be the basis of entirely abstract designs or pictures. In this example, the aim is to gain some further experience in modifying and developing a basic script form into lettering that is more interesting. It will also introduce a new simple technique using color. The design will be a finished work suitable for framing.

The first stage in any calligraphic design is to plan the design. This includes layout, page or sheet size, and the script style. Often the size will be determined in advance if the calligraphy is for someone else. In the case of this alphabet only the size of the available pens and paper will restrict the design. You will have seen that the letter heights are, to a great extent, determined by the pen width.

You will need several sheets of smooth paper for practice, one sheet of good quality paper for the finished piece, a pencil, a range of pen sizes, black ink, and a color.

Creating the design

1 *The possibilities using the alphabet for calligraphic designs are endless. Sketch a number of ideas in pencil. Be adventurous with lettering of different sizes and with the use of flourishes. If you prefer, you can use a small size square-edged pen for these sketches, but don't be too inhibited by technique at this stage. Although you will use only one of the designs, there may be elements in some of the others that can be incorporated into your final piece.*

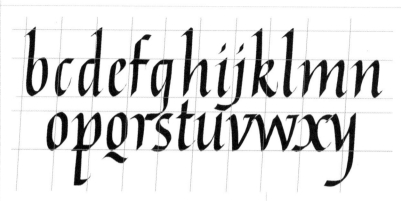

4 *Note that the descenders of the first line can clash with the second line. The descender of the j can simply be shortened. A more adventurous solution for the descender of the g is to combine it with the horizontal penstroke of the r. There will have to be some careful planning to get this right in the final design.*

2 *Choose a design you like. Make sure it is one that will give you some scope for enhancing the letters with flourishes and color. We will choose a design with a large A and Z, and the rest of the alphabet as two lines of lowercase letters. However, some of the flourishes in the sketches are worth considering also.*

3 *Using black ink and a large size metal pen, try writing the whole alphabet in two lines as in the sketch design. Don't worry about the A and Z or flourishes just now. Choose one of the basic styles that you have learned. Remember that very subtle changes in individual letters can make a significant difference to the overall appearance of text, even in a single alphabet. Keeping writing at a constant angle becomes easier with practice. Keeping consistency in height-to-width proportions is a little more difficult. Keep the lines fairly close together.*

6 *Ascenders, descenders, and some parts of some letters can be flourished to increase the decorative effect of the alphabet. Experiment with different styles of flourished ascenders on the d, h, k, and l and descenders on the f, g, j, p, and q. Try extending parts of the letters e, h, and k. In order to get some idea of how the flourish will work together, write groups of letters in alphabetical order.*

Flourishes can add interest to calligraphy if used well and with some restraint. Don't be overexuberant with them, as they can easily take on more importance than the lettering. When writing flourishes that comprise very long strokes, it can be difficult to control the pen, so avoid them if you are not confident of making long, smooth curves with a pen.

Adding flourishes

5 *Decide how the lines forming the letters (the serifs) will end. These can be very free or much more formal. The terminal strokes of all letters should be treated similarly, unless they are flourished.*

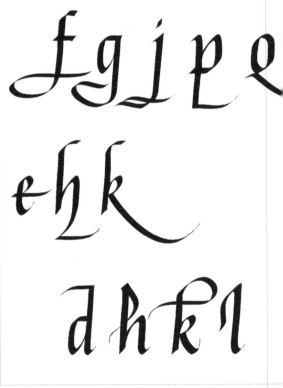

a a

g g

A Z

7 Some letters can be joined together or ligatured. The letter s joined to t is a good example (for more examples, see Project Two, pages 48–51). *However, you will find that some combinations don't work well while others do. You can also explore alternative forms for some of the letters—for example, a or g. Apply the flourishes to the alphabet as shown in the illustration. You will see that the flourish on the d mirrors the flourish on the l. In several places you will have to turn the pen as described earlier in the book* (see page 34). *Note that below we have not ligatured s and t because this would clash with g, but we have used the start of the w as part of the v. The capital A and Z will be enhanced with two simple additional penstrokes.*

bcdefghijklmn
opqrstuvwxy

You will see from this project that it is usual practice to plan a design in sketch form and then work out the various elements separately. We have decided on the letterform, the flourishes, and the treatment of the two large capital letters. The calligraphy can now be assembled. Some additional decoration can be added if you wish. The calligraphy will be in two colors. You can use the red and black, as demostrated here, or choose any two colors of your own.

Completing the design

8 *On the paper that is to be used for the final design, rule guides in pencil as usual. The large letters A and Z will be written with a very large pen or one made from card or wood (see Project Four) and positioned on the left and right of the alphabet. Write the alphabet carefully in black, incorporating all the flourishes and ligatures that you have planned.*

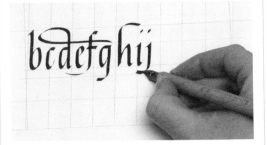

9 *When you are sure that the ink has dried, add the two large capital letters in red or another color of your choice. This is a relatively simple design that doesn't take long to write. If you are unhappy with the result, mark the changes you want to make directly on your work and repeat the process. Calligraphers frequently produce several copies of smaller experimental pieces before settling on the one with which they are satisfied. So don't worry if your first effort is not as good as you hoped!*

11 *If you plan to frame the alphabet, make sure that you make the bottom margin of the paper or the mount slightly larger than the two sides and top. If you don't, it will look too low in the frame.*

10 *You can accept the calligraphy as it is or add some further embellishment. Using the same pen (or a bamboo pen) and black ink, write the capital A and Z over the letters a little below and to the left, carefully following the original penstrokes. Don't worry if the black ink lifts the red a little. This can enhance the effect.*

77

PROJECT EIGHT

A concertina manuscript book

WRITING MANUSCRIPT BOOKS WAS the principal occupation of medieval scribes. These books, including such volumes as the *Book of Kells* and the *Lindisfarne Gospels*, are considered to be amongst the greatest masterpieces of world art. Manuscript books are still produced today by calligraphers. They range from large books for ecclesiastical or civic purposes to small craft items of only a few pages. This project introduces some of the principles of using calligraphy in a multi-page situation. For the project, you will need a sheet of good quality, fairly stiff paper (at least 11¾ x 16½ inch in size), paper for practice, a range of pen nibs, and black and red inks. If you have other colors, this will extend your opportunities. The text we will work with is a nursery rhyme, but you can change this to anything you like.

The structure of the book, layout, and text

1 *The book will be made from a single piece of paper, folded to make four leaves plus a cover. 11¾ x 16½ inch is the smallest practical size for the book, otherwise the calligraphy will have to be extremely small to fit the page. Try folding paper into the concertina shape and decide what size is practical for you. If you want a squarer proportion than you get from standard paper sizes, you can work on the full-size sheet and trim it afterward.*

2 When you have chosen your paper and worked out the page size from it—i.e. the height by one-fifth of the sheet width—you can then think about the layout of each page. A very traditional layout has the top and side margins roughly equal and the bottom margin a little larger. One of the side margins might be made larger or the top margin dropped low on the page, perhaps leaving room for a heading or some other element of the design. In multi-page work, it is important that there is some standardization of margins, otherwise the design becomes visually disturbing. As we have only four lines of text for each page in our example, we will have a large top and bottom margin.

3 Write out one of the verses of the poem. Try different calligraphy styles, sizes, and widths. Vary the ascenders and descenders. Use color for initial letters or write a larger letter at the beginning of the verse. Pay particular attention to line spacing.

The cuckoo is a lazy bird,
She never builds a nest,
She makes herself busy
By singing to the rest.

The cuckoo is a lazy bird,
She never builds a nest,
She makes herself busy
By singing to the rest.

The cuckoo is a lazy bird,
She never builds a nest,
She makes herself busy
By singing to the rest.

The cuckoo is a lazy bird,
She never builds a nest,
She makes herself busy
By singing to the rest.

Poetry is a popular theme for calligraphers. This literary form seems to lend itself to a handwritten transcription better than to more formal typefaces. However, restrictions imposed by the structure of lines and verses limit design opportunity and make it difficult to create something very original and creative. Much can be done with the title of the poem. Highlighting initial letters in a different color can add interest. The form of the book itself can also create opportunities to design something unique.

5 *To add interest, the initial letters of each line will be in a contrasting color. Also, each alternate line can be in a slightly different color—in the example, black alternating with dark brown. Alternatively, you could use graduated color. Pour out a little black ink into a small container. Fill your pen and write the first line. Add a little color to the black ink and write the second line. Add more color for every line. Obviously, this would be more effective with much larger blocks of text.*

Developing the text

4 *Each of the four verses will have a page each. As they form an almost square text block, we will have a large space above and/or below. We can make effective use of this space by removing the first word of the verse, enlarging the initial letter and placing this in a large size above the text. This will create a more satisfactory vertical shape.*

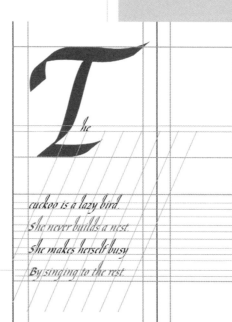

The

o is a lazy bird,

ever builds a nest,

nakes herself busy

nging to the rest,

6 *Try modifying the ascenders and descenders. The script form used in this example is a modification of italic. The ascenders are very long and have an exaggerated reverse flourish made by using the pen-turning technique* (described on page 34).

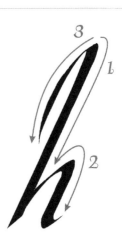

7 *Mark up your paper lightly in pencil, with the margins and text positions. Don't forget to indicate where the folds of the book will be. Rule guidelines for the text. If you are working on large paper, you will probably have to use a small pen size.*

Usually, calligraphy is written on one side of the paper. With this little manuscript book, you will be using both sides, so it is important that you keep the underside of the paper very clean throughout the above procedures. Placing an extra piece of paper below the one on which you are working can do this. If you are writing a much larger manuscript book with many pages, the procedure would be the same as you have gone through here.

The cuckoo is a lazy bird,
She never builds a nest.
She makes herself busy
By singing to the rest.

She never hatches her own young,
And that we all know,
But leaves it for some other bird
While she cries Cuckoo.

And when her time has come
Her voice we no longer hear,
Where she goes we do not know
Until another year.

The cuckoo comes in April,
She sings her song in May,
In June she beats upon the drum,
And then she flies away.

Completing the book

8 *Write out the full text of the poem on the prepared paper. Use black for most of the text and add a bit of interest by picking out the initial letters of each line in red. If you have access to colored pigment, the text of each alternate line or page can be in a different color. Dark brown works well. You can create a good dark brown pigment by mixing black with a little red. Don't be afraid to make last minute changes. Here the "he" of "The" and "She," and the "nd" of "And" have been moved to a better location.*

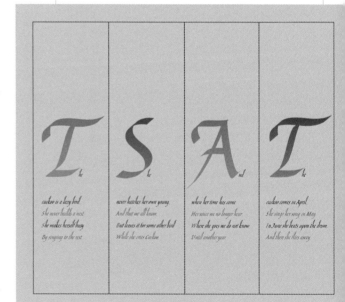

9 *Design the cover title word. This can contrast with or complement the text style in the book. Be careful not to make the forms only slightly different, as this will look like a mistake. Either make them the same or significantly different so that there is no visual ambiguity. We will use the same modified italic style as the main text of the poem and use capitals for the word "THE." Rule up the sheet and write the title.*

10 *When the ink is dry, very carefully fold the sheet as shown in the above illustration. Erase all pencil guidelines. If necessary, with the book fully folded, a final trim can be made of the top and bottom edges. Do not take off more than $\frac{1}{16}$ inch or so as this will affect the top and bottom margins. For this, use scissors or, better yet, use a sharp utility knife and steel rule or straightedge.*

PROJECT NINE

A self-written brief

THIS IS A PROJECT that enables you to demonstrate the skills you have gained by working through the book and the previous eight projects. Choose text that you would like to use for your calligraphy. Something with about 200–300 words would be best, as this will give you the chance to work with a large area of calligraphy in a fairly small pen size. Some guidance is given on the next page. This includes reminders of some of the important points and good practice that have been detailed earlier.

Left The letters of the alphabet can be used to stunning effect as shown here.

Some suggestions to include

There are many things to consider when planning to write a piece of calligraphy. As with previous projects, start with a sketch idea and then explore the various elements that make up the design. You might also like to consider some of the following ideas.

Think about the use of a large initial letter in at least two colors to contrast with the main text. This doesn't have to be the first letter. It may be possible to incorporate a large letter part of the way through the text and either wrap the text around it or open up the design with lots of white space. Consider using graduated color to add interest to the main text. This can start with one color, change gradually to another and then back again, or you could alternate the colors for every other line. Perhaps flourishes can be included somewhere in the design and an end piece might complete it nicely. Be adventurous in using scale, color, and texture.

Work through a logical sequence from initial sketches to writing the final, carefully planned calligraphy. Follow these steps.

1 Begin by sketching your ideas as pencil thumbnail layouts first. Your first idea will not necessarily be the best one. Make sure that your sketches represent the amount of text you have to work with. Think about the size, position, and lettering style of a heading. Explore landscape, portrait, and square formats. Perhaps use capitals and lowercase calligraphy in different parts of the layout.

2 Try out some text in different pen sizes to match your layout sketches. Work out your main text, its style, the formation of the ascenders and descenders, size, line spacing, and any flourishes that you want to incorporate. Keep a careful note of the pen sizes you use—you may want to come back to them.

3 Design the initial letter (if you are including one) or any headings. It's a good idea to contrast the style as well as the size with the rest of the text. Plan the color, and any flourishes or decoration. A large letter could be written freely with a bamboo pen, alternatively you could make a pen from wood or card stock to get the size you want.

4 Prepare a full size layout on practice paper, using the pens you think will be suitable for the final piece. You can try out color at this stage or work in black only.

5 Cut up the draft layout and prepare a paste-up with the text and any other elements accurately positioned. If something doesn't work, rewrite that part and try it in position. Mark the pen sizes on the paste-up if you find this helpful.

6 Design and position the finishing piece if you want to include one. Be careful that this doesn't dominate the design.

7 Use a good, smooth paper and rule it up for your finished work lightly and carefully in pencil. Include margins and any other necessary guidelines. Rule the slope of the letters if this helps your calligraphy. If you have a large initial letter, sketch this in pencil also.

8 Write and color the initial letter. Remember, if you make a mistake at this stage it is still less work than if something goes wrong later and you have to start again.

9 Write the main text. You should aim for accuracy and good calligraphic form, but if you write an occasional bad letter, don't let it disturb the flow of writing. Chances are it will not be noticeable in the overall block of text.

10 Finish with the end piece, if included. Remove any pencil guidelines and trim the paper if necessary.

Gilding

GOLD APPLIED WELL TO a manuscript certainly adds an air of opulence; used badly, it can make calligraphy look cheap and a little bit shabby. Gilding is a craft that is learned only after much practice, and you cannot expect to be able to achieve in a short time the bright, smooth effects that we see in good examples. However, there are ways of achieving results that will give you some satisfaction.

Gold pigment, either ink or paint, can be applied with a brush or pen. The results can be very disappointing. Although you can achieve a fairly smooth, even gold, it will be rather dull and will lack brilliance. The alternative method is called "raised" gilding. A gesso ground, traditionally made from plaster, sugar, lead, and size, is applied to the paper so that it is raised slightly from the surface. A sheet of real gold leaf is applied to this surface and burnished to a bright, gleaming finish. When pages of a manuscript book are turned, the gold on the raised ground catches the light—hence the term "illumination." Some calligraphers still mix their own gesso or purchase it from specialist suppliers. However, there is another method that makes raised gilding a little easier for the novice, although the brilliant results achievable with the traditional preparations will not be possible.

Instead of using gesso, PVA adhesive can be used. This white glue must be the sort that remains flexible when dry. The procedure is as follows.

Gold ink or paint, although useful in some situations, does not have the brilliance of raised gilding.

1. First, on your chosen piece of paper, draw the letter or letters carefully in pencil.

2. The shape is filled with PVA adhesive, creating a "raised" effect.

Draw a light outline of your letter. Using a brush, paint the letter with the adhesive so that it has a slight thickness. You might have to thin the PVA with a little water. When the adhesive has dried, breathe gently on it. This makes the surface slightly sticky. Apply gold leaf to the letter(s), ensuring that it is firmly

stuck to the PVA. The gold leaf will not stick to the paper. Burnish the letter(s) with a steel or agate burnisher. Remove the surplus gold leaf with a brush. One drawback with PVA is that it is difficult to apply a second layer of gold if any part has been missed, so it is important that you get it right first time.

3. When the PVA is dry, real gold leaf is applied to the letter and pressed firmly on it. The gold will adhere to the PVA and not the paper.

4. And finally, the gold leaf is burnished to a dazzling bright finish.

Layout and design

Above Always plan your layouts by sketching ideas as pencil "thumbnails." When you have chosen the best layout, it can be roughed out full size.

THE DESIGN OF A PIECE of calligraphy can enhance or spoil what could otherwise be a good piece of work. Some of the principles of good design have been introduced in the projects. The layout of the text, margins, and any decoration should support the overall concept. A design can be a balanced, centered arrangement or offset in some way for effect.

When you use different writing styles or sizes, make them very different so that a good contrast is achieved. If the scripts are too similar, it will look wrong. Similarly, if you intend to position the elements so that they align with each other, make sure that they do.

Above all, keep in mind that the white space around your calligraphy is as important as the text. Use it for effect. A single initial letter or decorative element in a margin, with the rest of the text as a simple rectangular block, can be as effective as a much more complex arrangement. It is often wise to keep things simple.

Below White space round a text is as important as the text itself. Here the flourishes on the left side of the large capital N break into the margin.

Having acquired a formal hand the penman may modify and alter it, taking care that the changes are compatible, and that they do not impair its legibility or beauty. Such letters as are obsolete he replaces by legible forms akin to them in feeling, and, the style of the selected type becoming very naturally and almost unconsciously modified by personal use, he at length attains an appropriate and modern Formal Handwriting. The process of forming a hand requires time and practice: it resembles the passage of Copy-book into Running hand, familiar to us all.

N

ot only must the copier ascertain what the forms are like and what are their proportions, but he must try to find out how they are made, for the matter of making a letter, or even a single stroke, affects its forms and character with a definite tendency. And this becomes more marked the faster the writing. An apparently right form may yet be wrongly - if slowly - made; but in rapid writing, a wrong manner of handling the pen will inevitably produce wrong forms. As the real virtue of penmanship is attained only when we can write quickly, it is well worth training the hand from the beginning in the proper manner.

E ntre b
la ver

Above Simple contrast in scale can be very effective.

Where to go from here

THIS BOOK IS AN INTRODUCTION to calligraphy. You will want to further develop what you have learned. There are many how-to calligraphy books on the market and you will find some of the better ones listed below. Some of these may be helpful and even provide inspiration, but you may learn more from books that illustrate good examples of both historical and contemporary work. These will give you ideas that will help you develop your calligraphy and devise new calligraphic scripts. They will also give you ideas for projects and layouts.

If you have access to the Internet, you can browse calligraphy Web sites, many of which have galleries of work.

Another good way to learn is to join a local or national calligraphy society. Through such a society, you will get the chance to meet other budding calligraphers, as well as experienced ones, and to learn from them. They may also give you the opportunity to exhibit your work so that you can celebrate your achievements.

Select bibliography

Anderson, Donald M. *The Art of Written Forms. The Theory and Practice of Calligraphy*. New York: Holt, Reinhart, and Winston, 1989.

Child, Heather. *Calligraphy Today. Twentieth Century Tradition and Practice*. New York: Taplinger, 1988.

Daubney, Margaret. *Calligraphy*. Marlborough: Crowood, 2000.

Drogin, Marc. *Medieval Calligraphy. Its History and Technique*. New York: Dover, 1989.

Gray, Nicolete. *A History of Lettering*. Oxford: Phaidon, 1986.

Guillick, Michael and Rees, Ieuan. *Modern Scribes and Lettering Artists*. London: Studio Vista, 1980.

Halliday, Peter. *Calligraphy. Art and Colour*. London: Batsford, 1994.

Halliday, Peter. *Creative Calligraphy*. London: Kingfisher, 1990.

Halliday, Peter (editor). *Calligraphy Masterclass*. London: Bloomsbury, 1995.

Harvey, Michael. *Creative Lettering Today*. London: A. & C. Black, 1996.

Jackson, Donald. *The Story of Writing*. Monmouth: Calligraphy Centre, 1994.

Jean, Georges. *Writing. The Story of Alphabets and Scripts*. London: Thames and Hudson, New Horizons series, 1992.

Modern Scribes and Lettering Artists II. Contemporary Calligraphy. New York: Taplinger, 1986.

Web sites

Association for the Calligraphic Arts (USA)
http://www.calligraphicarts.org/

Atlanta Friends of the Alphabet (USA)
http://www.friendsofthealphabet.org/

Calligraphy and Lettering Arts Society (UK)
http://www.clas.co.uk/

Calligraphic Society of Arizona (USA)
http://www.calligraphicsocietyofarizona.org/

Carolina Lettering Arts Society (USA)
http://www.carolinaletteringarts.com/

The Edward Johnston Foundation (UK)
http://www.ejf.org.uk/ejf.html

New York Society of Scribes (USA)
http://www.societyofscribes.org/

Society of Scribes and Illuminators (UK)
http://www.calligraphyonline.org/

Washington Calligraphers' Guild (USA)
http://www.calligraphersguild.org/index.html

Glossary

aligned left Text arrangement in which the lines begin at the same vertical position to the left, giving an uneven right-hand margin.

aligned right Text arrangement in which the lines begin at the same vertical position to the right, giving an uneven left-hand margin.

alignment The positioning of text on the page. The text can be aligned right, aligned left, centered, or justified.

alphabet A code comprising a limited number of symbols or characters that, combined in various ways, represent a language.

archival Retaining quality over time. Inks and other pigments vary in how long they can be exposed to light before the color changes.

ascender The stroke of lowercase letters that rises above the x-height.

baseline The bottom line of the x-height.

bowl The closed curve of letters such as b, d, p, and q.

branching stroke An arching stroke that arises from a down stroke of a letter.

broad-edged pen A pen with a writing tip that has a chisel-shaped end. Also see square-edged pen.

calligraphy Writing as an art; beautiful writing; penmanship.

capitals The initial or "large" letters of an alphabet.

copperplate (of writing) A script form in which the thick and thin lines are produced by pen pressure on a sharp, pointed, flexible nib and comprising complex loops and curves.

centered Text or image placed at an equal distance from the left and right margins.

counter The space contained within round parts of letters.

cuneiform Possibly the earliest form of written communication used by the ancient Mesopotamians and comprised of characters constructed from wedge-shaped elements impressed on clay.

cursive In the lettering sense, scriptlike, flowing.

descender The part of lowercase letters (such as g, y, and q) that lies below the baseline.

fine art Creative paintings, sculpture, drawings, and prints.

flourish A (non-essential) embellishment added to a letter.

hieroglyphics A form of written communication that uses a combination of pictures and symbols, most commonly used to refer to one of the writing styles of the ancient Egyptians.

italic A style of cursive calligraphy and writing developed in Italy in the Renaissance. Also a

slanting version of a typeface, sometimes of a slightly different and more cursive style.

justified text A block of text that has straight right and left margins.

legibility At its simplest, this means how well text can be read. A complex concept that includes readability, visibility, and comprehension.

letter spacing The space between letters. This is different from the physical distance between letters.

ligature Two or more letters joined together to make a single alphabetic symbol.

line space The space between lines of text.

margin The white spaces around text blocks.

medium (plural media) The process or material used to create art works or designs.

nib width The width of the writing end of a broad-edged pen.

papyrus A grass grown in the eastern Mediterranean that was woven into flat sheets and used by the ancient Egyptians and other early cultures as a writing surface.

parchment A writing material made from animal skin, including calf (as vellum), sheep, goat, and even human.

pen angle The angle the writing tip of the broad-edged pen makes with the horizontal writing line.

ragged left See ranged right.

ragged right See ranged left.

ranged left A line or block of text aligned with the left margin.

ranged right A line or block of text aligned with the right margin.

serif The strokes at the end of a letter's main strokes.

slope The angle that the vertical lines of letters make with the horizontal writing line.

square-edged pen A pen with a writing tip that has a chisel-shaped end. Also called a broad-edged pen.

style The character of a letterform.

texture In the physical sense, the quality of a surface. Texture can also be visual.

thick (stroke) The broad line produced when writing with a broad-edged pen.

thin (stroke) The thin line produced when writing with a broad-edged pen.

uncials An early form of writing that lacks capitals and that was developed from the Roman scripts.

unjustified Text that has a straight right or left margin with the opposite margin uneven (ragged).

vellum A writing material made from calfskin, widely used by Dark Age and Medieval scribes.

word spacing The distance between words in text.

x-height The height of the lowercase letter x, used to describe the main part of the letter.

Index

Page numbers in *italic* relate to
references in illustration captions.

Acknowledgments

I WOULD LIKE to thank Sue Gunn for her contributing projects, the Bookplate on pages 52–55 and the Wedding Invitation on pages 62–65. Thanks go to Maureen Sullivan for permission to reproduce her calligraphy "Lord of the Dance" on page 42, with a credit to Sydney Carter. I also thank Rebecca Saraceno for her constructive support throughout the writing and editing of this book.